light show

"There are darknesses in life and there are lights, and you are one of the lights, the light of all lights."

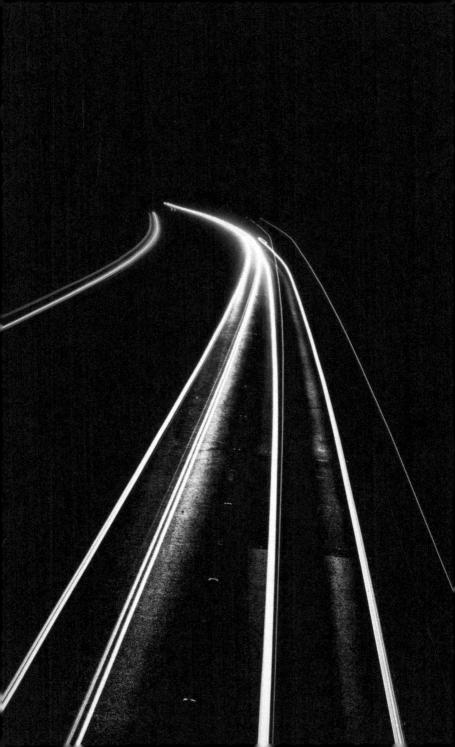

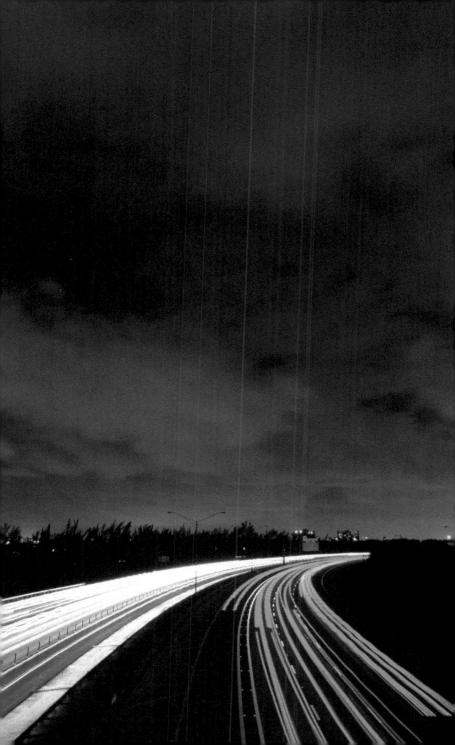

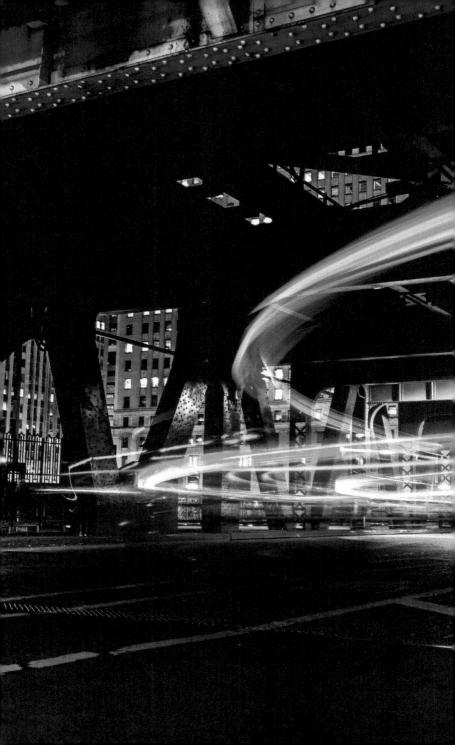

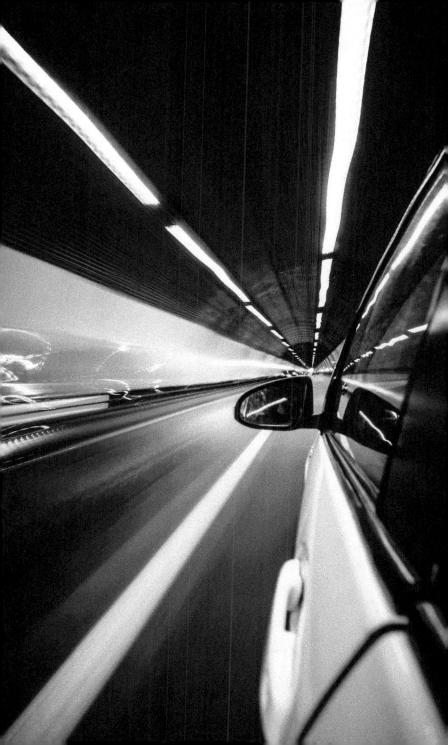

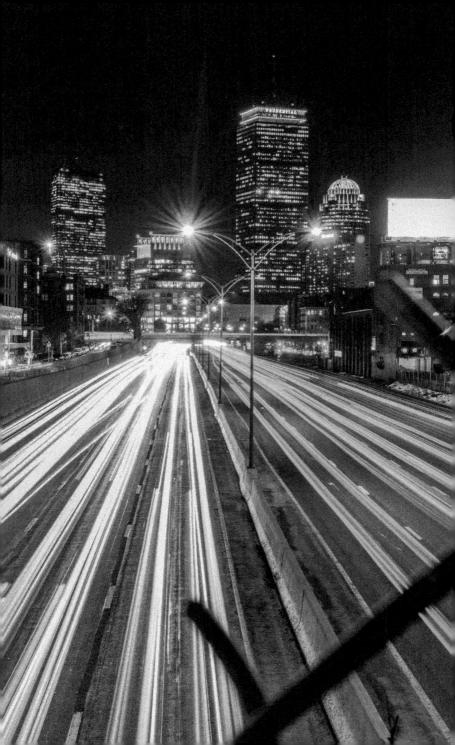

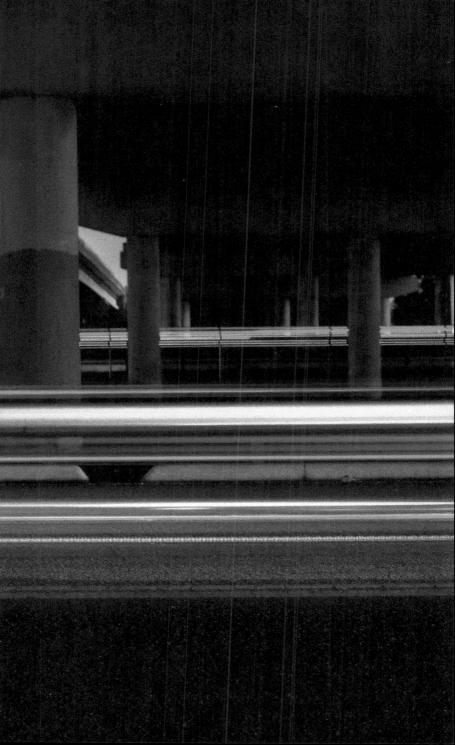

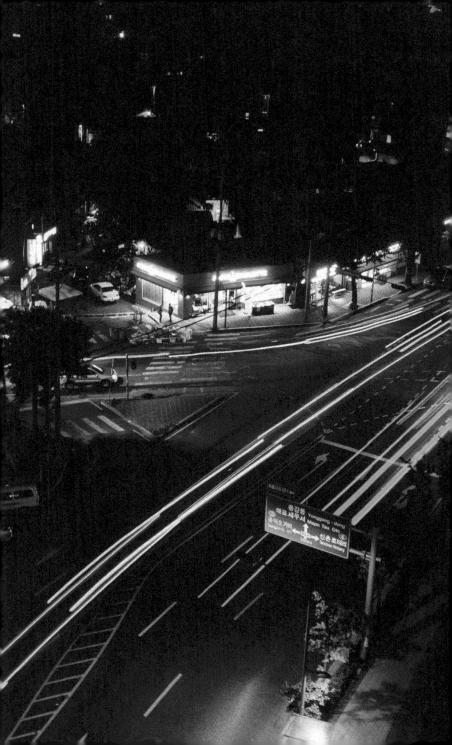

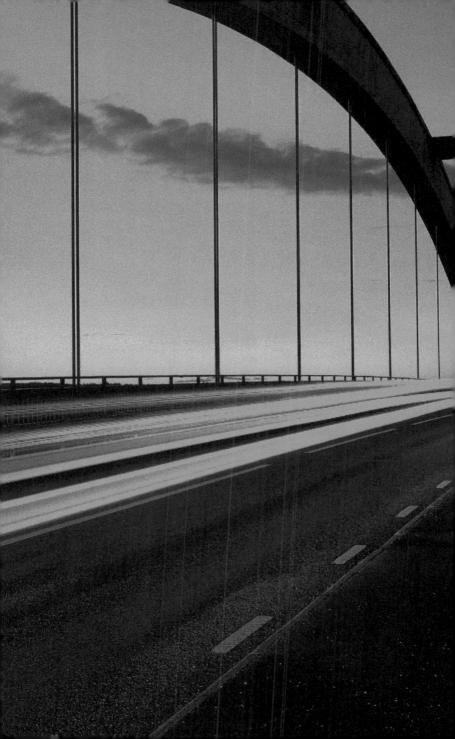

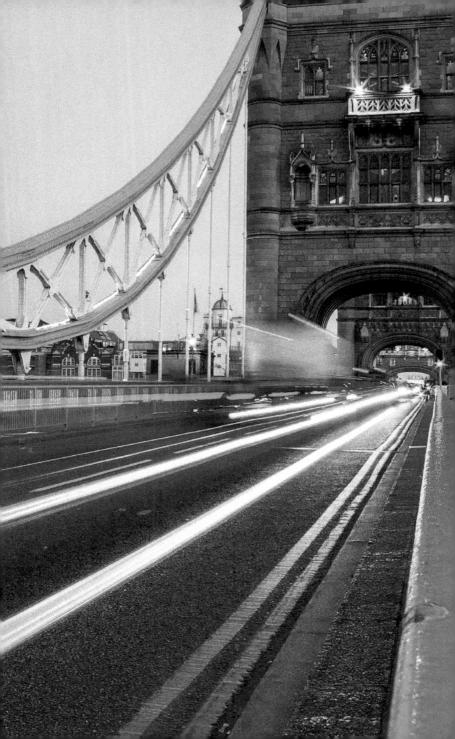

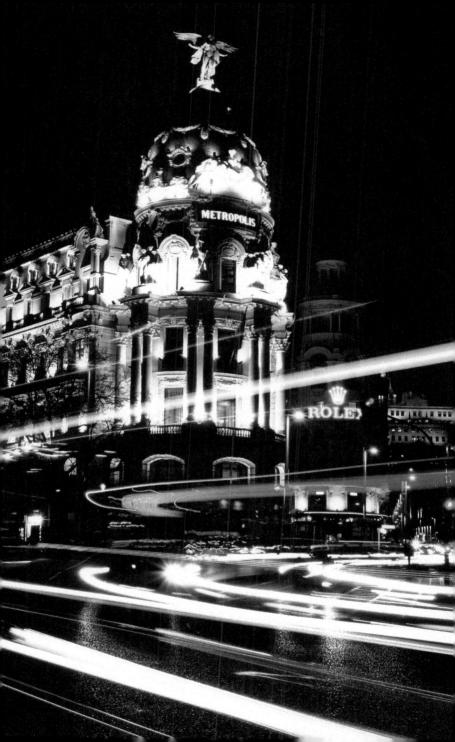

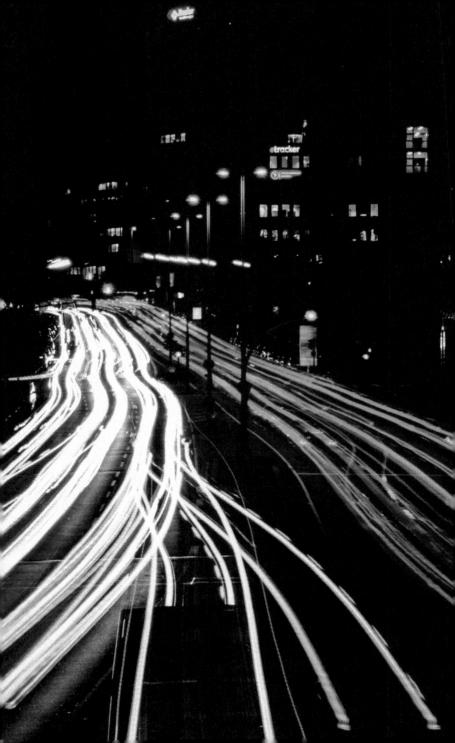

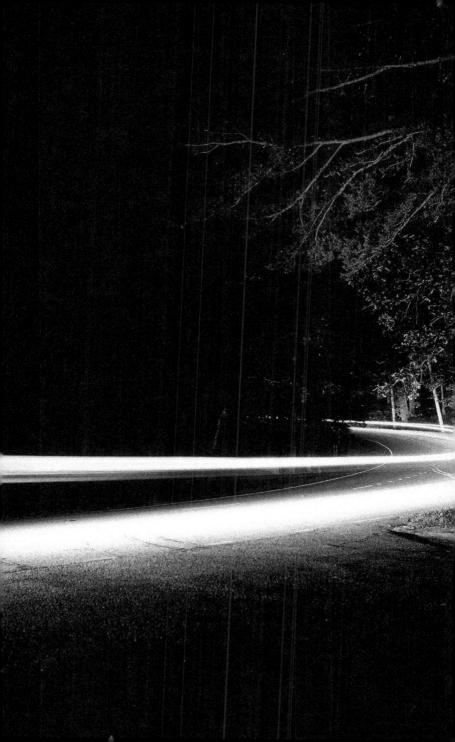

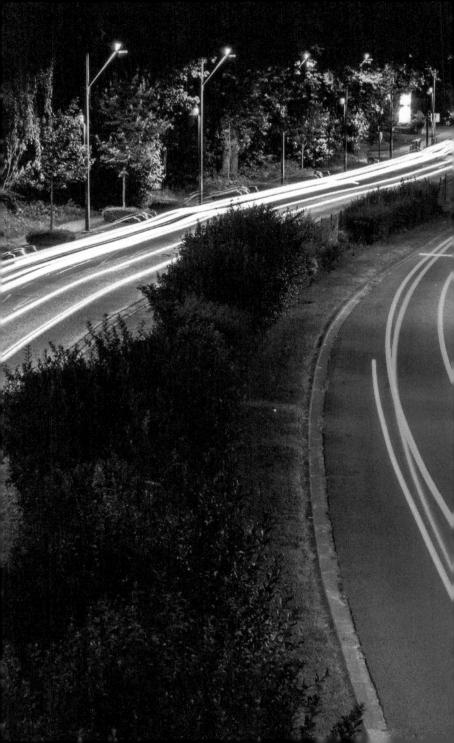

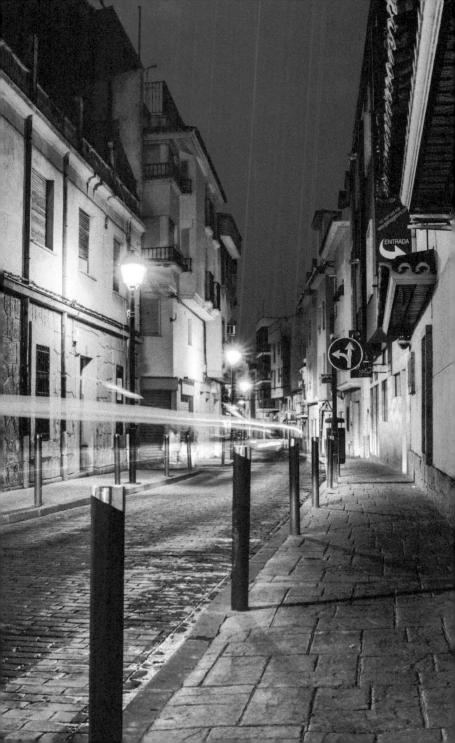

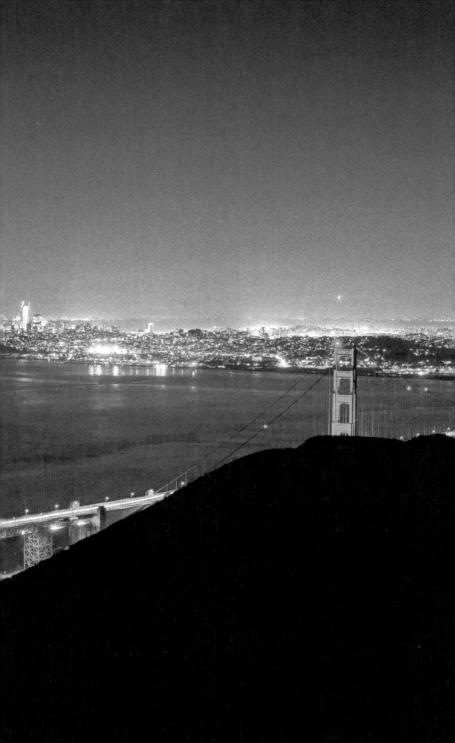

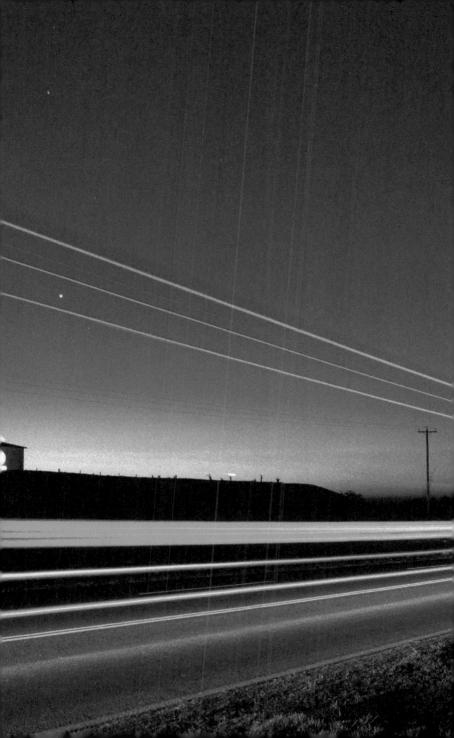

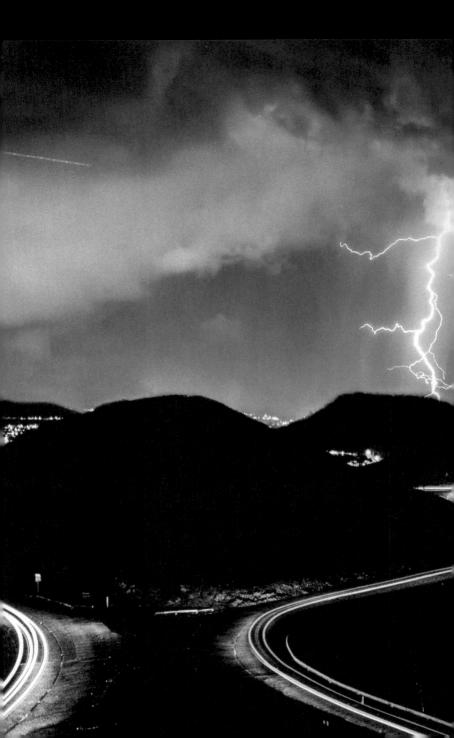

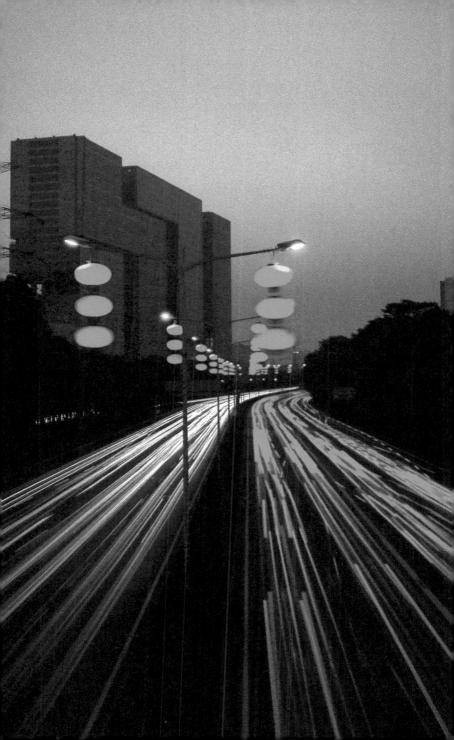

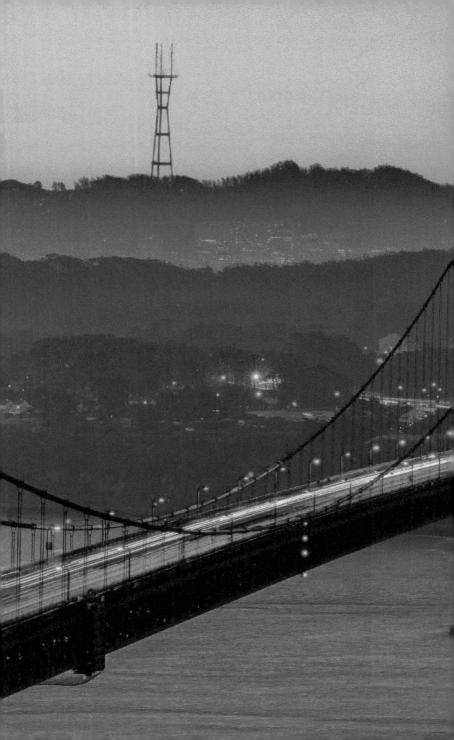

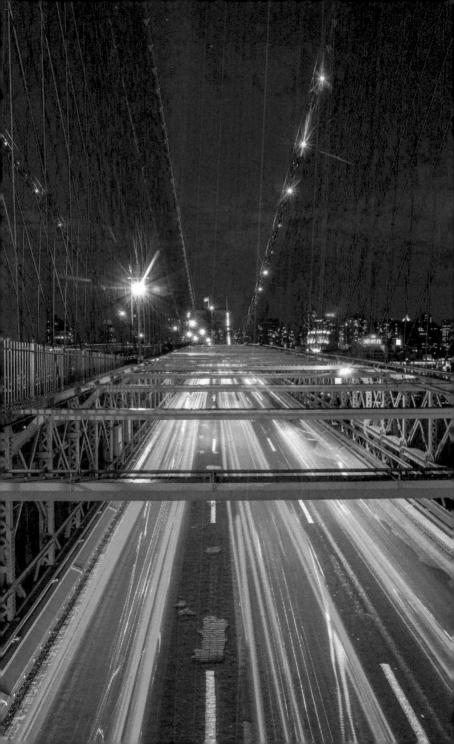

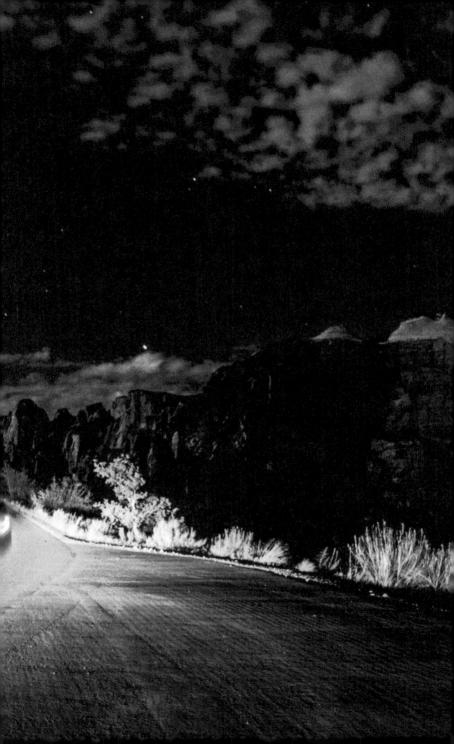

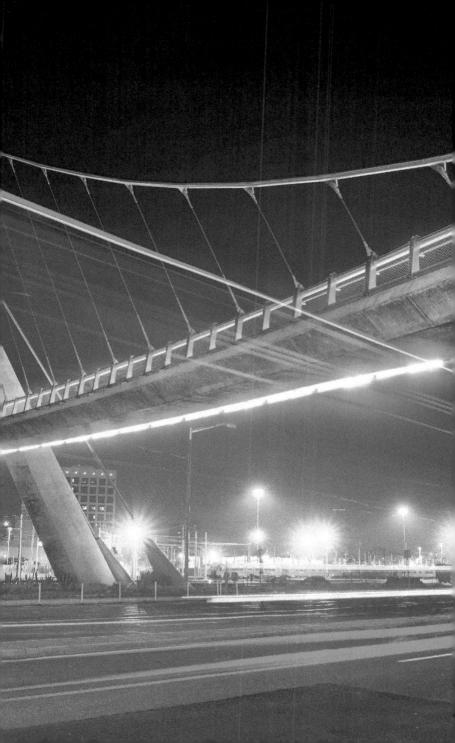

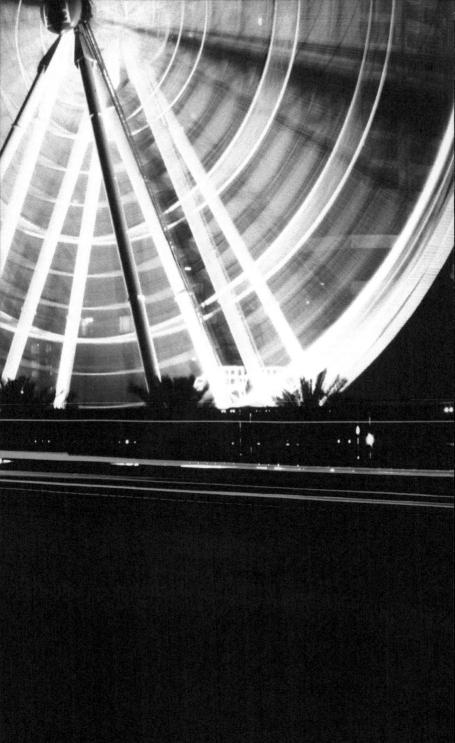

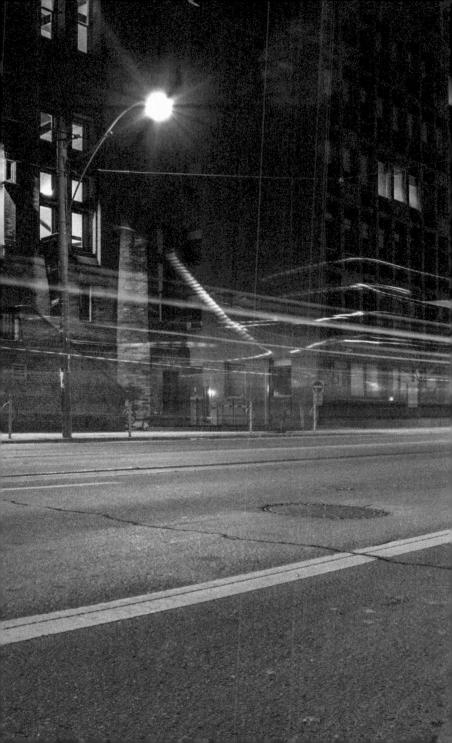

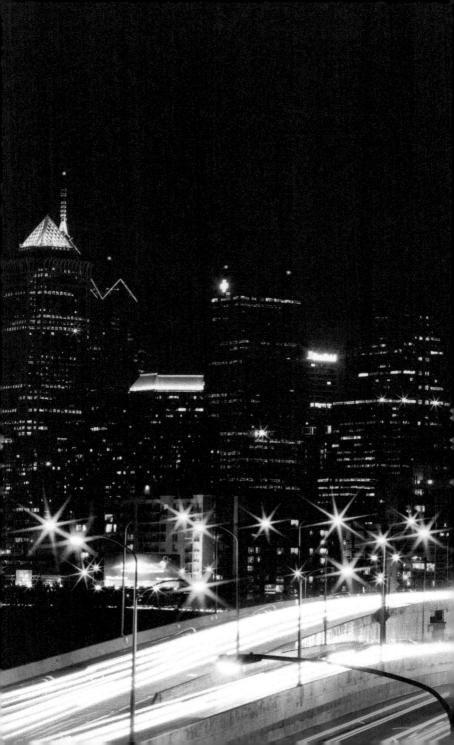

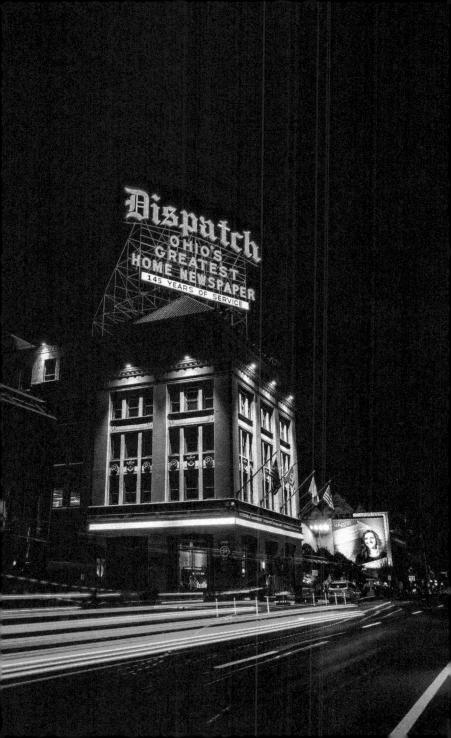

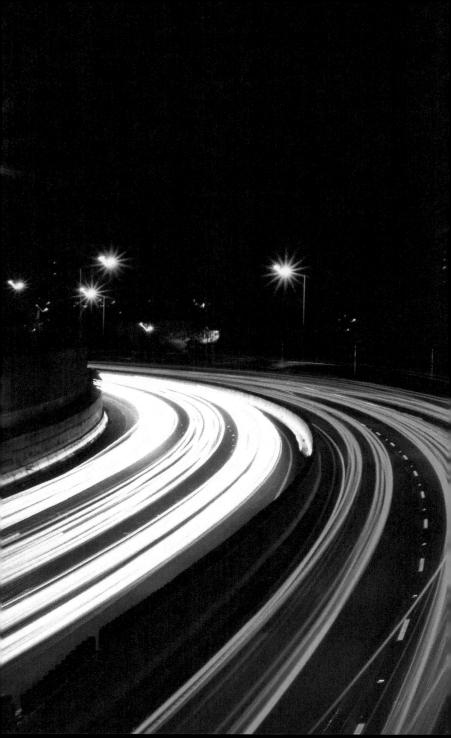

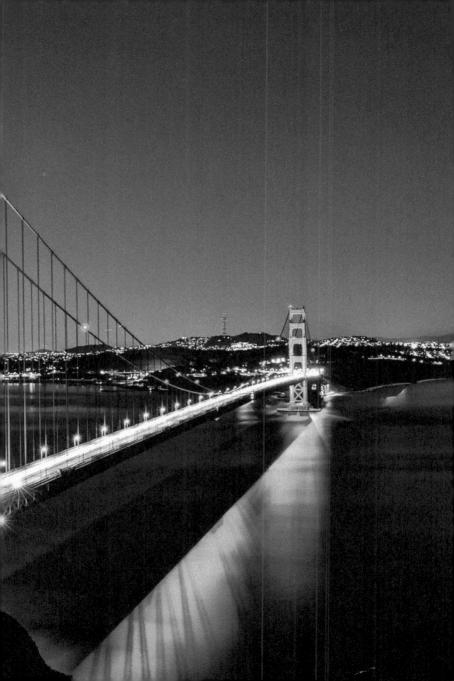

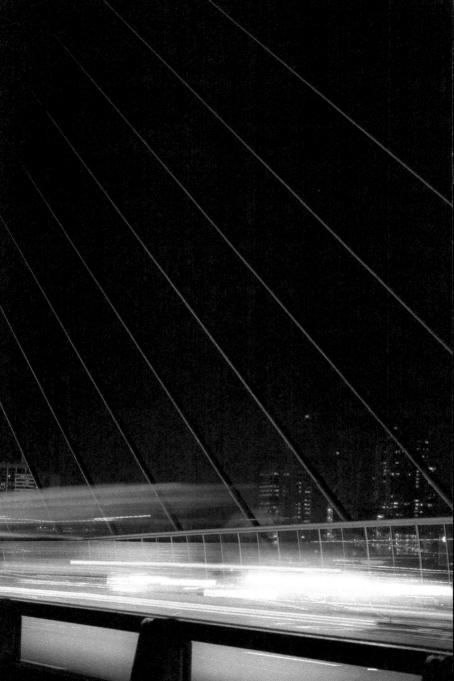

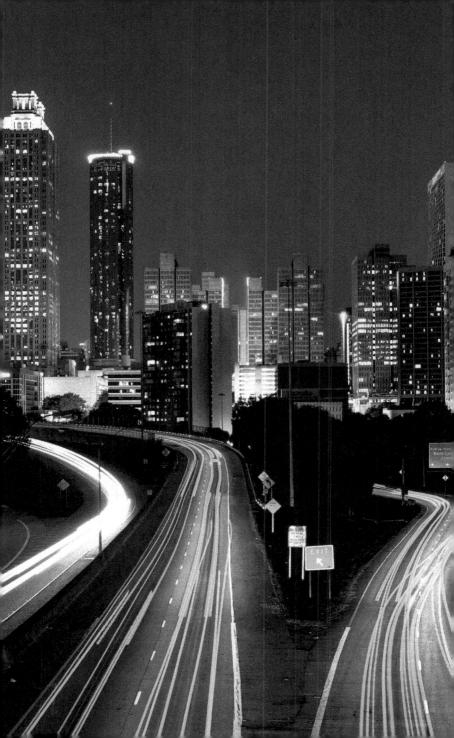

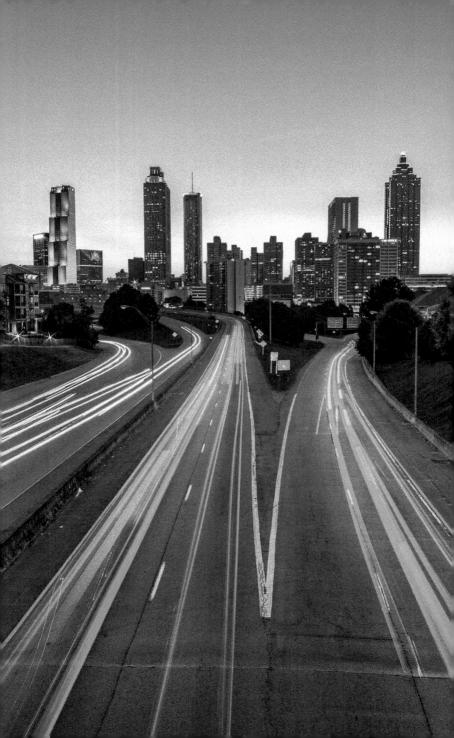

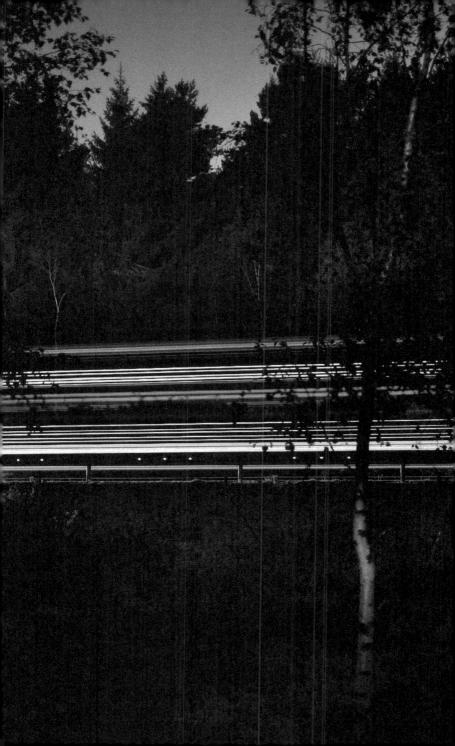

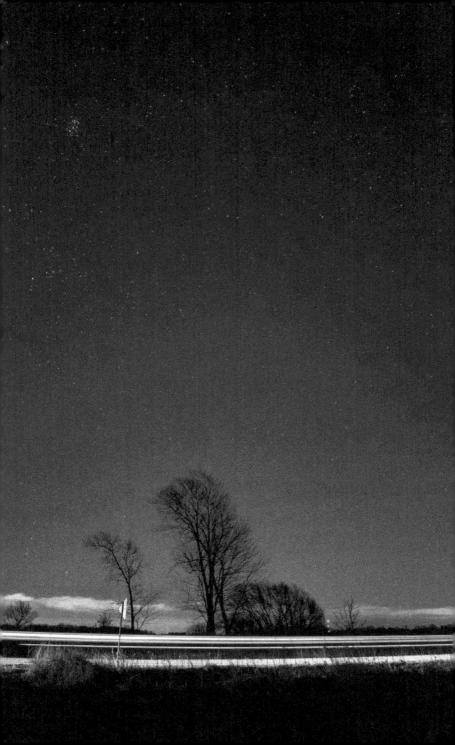

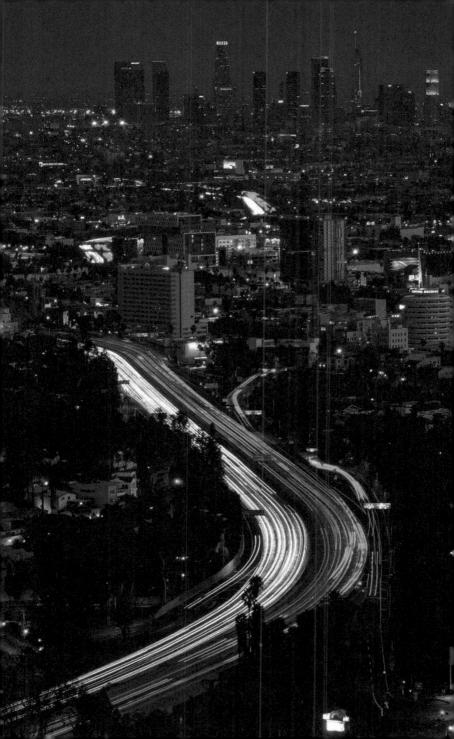

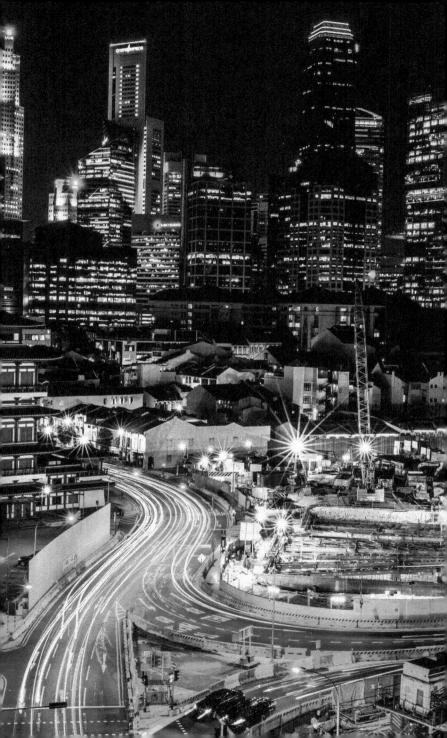

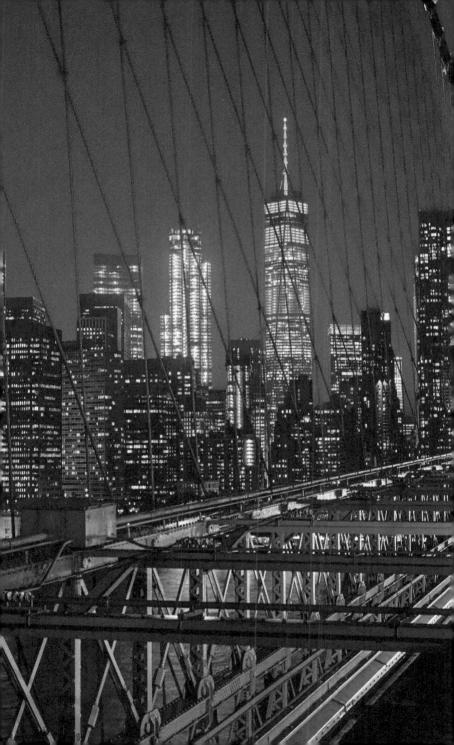

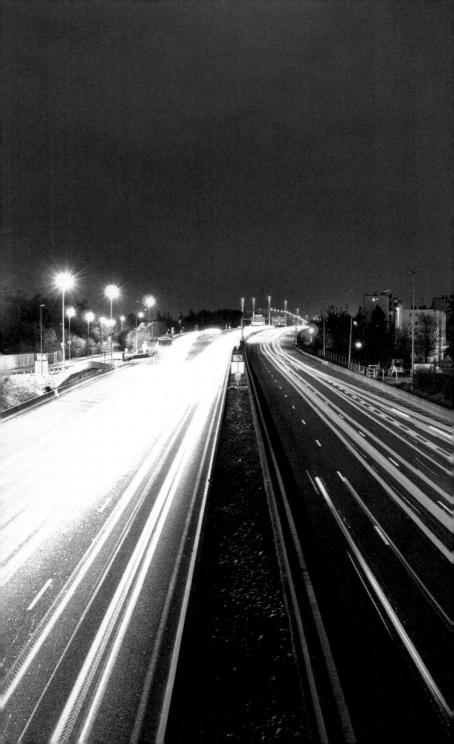

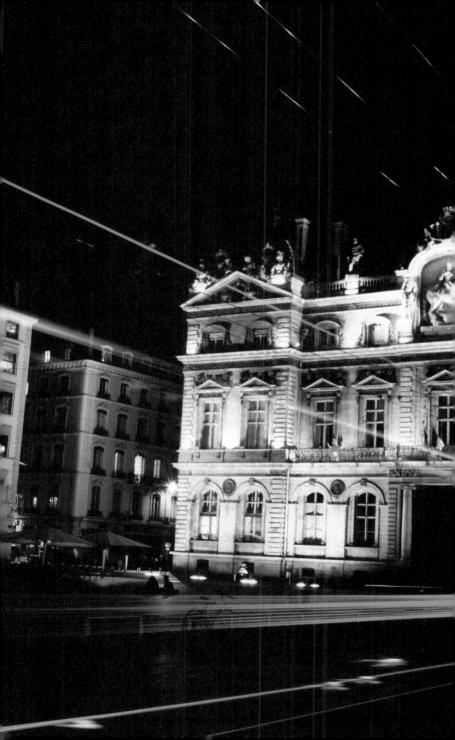

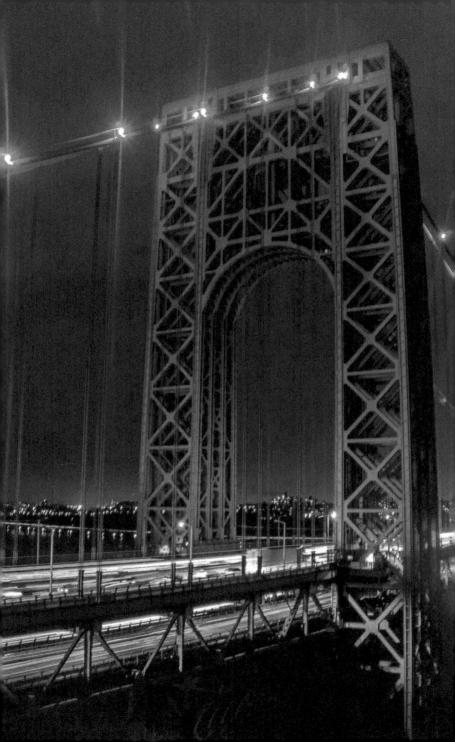

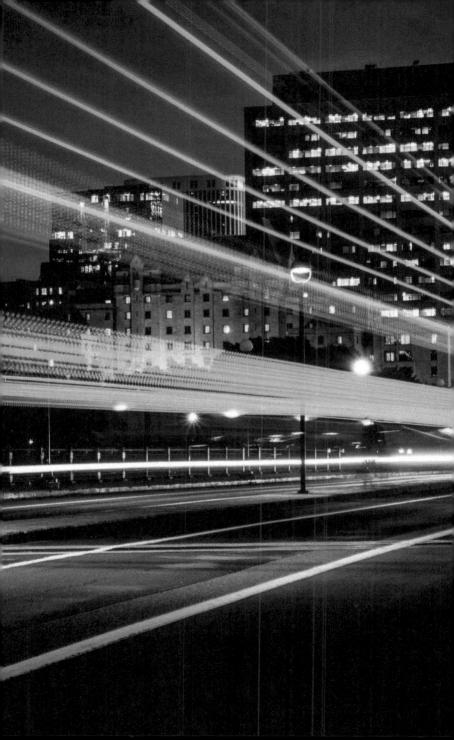

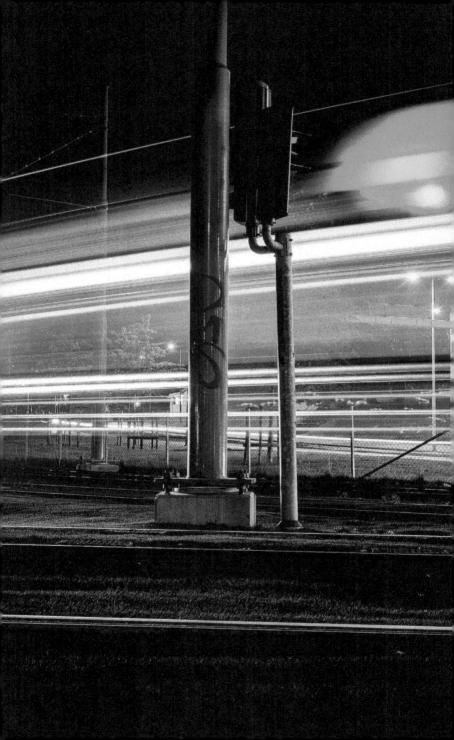

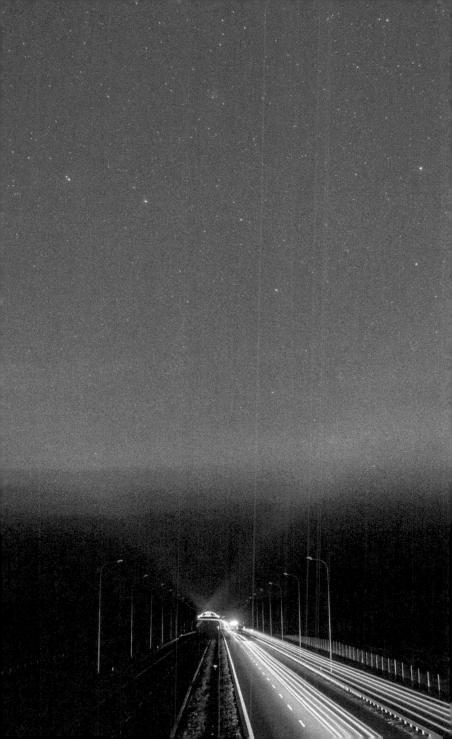

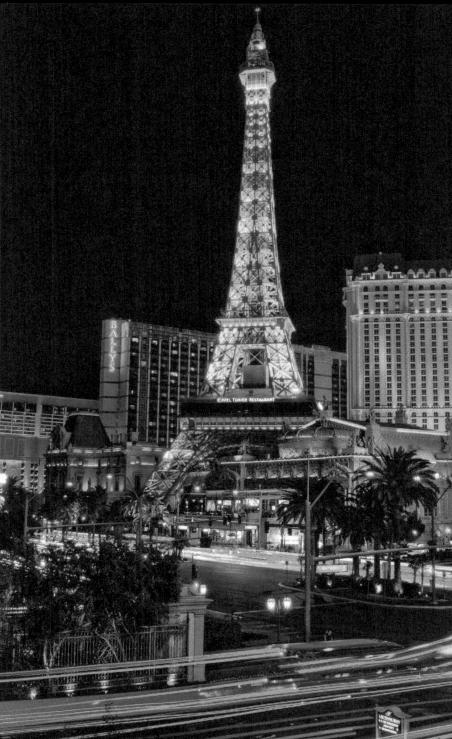

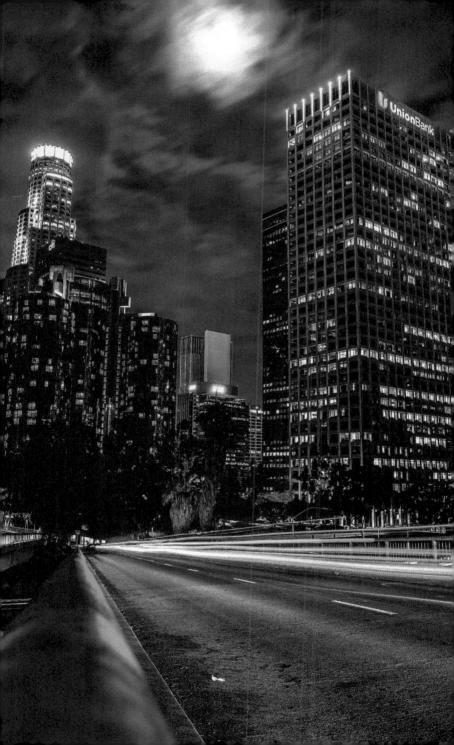

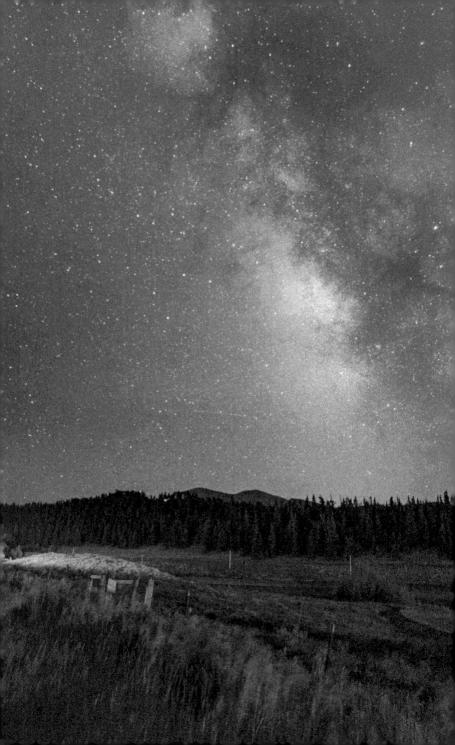

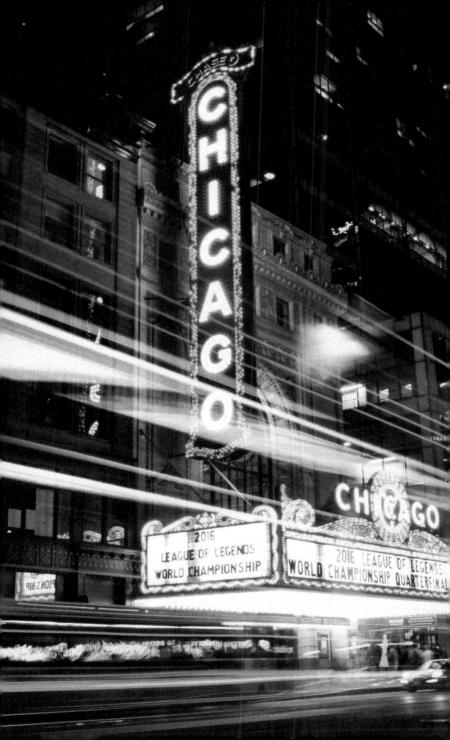

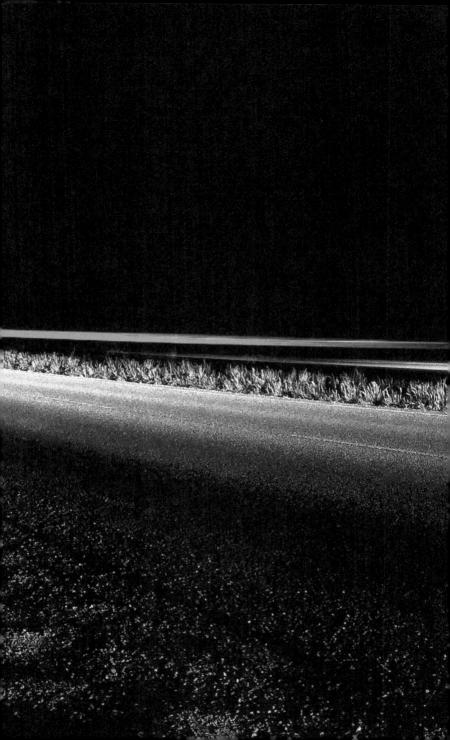

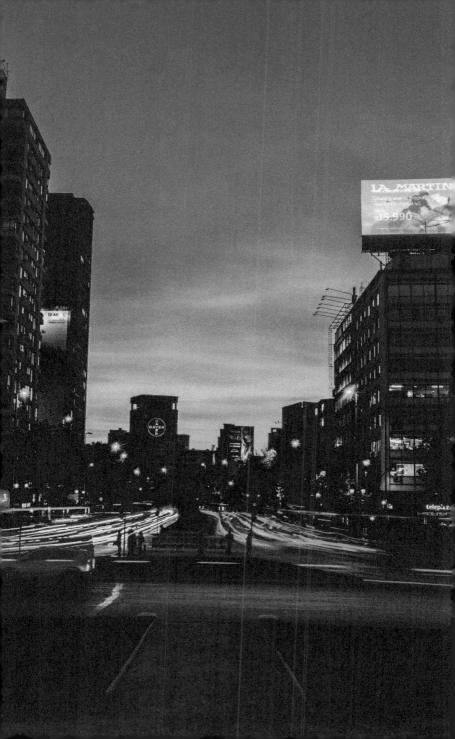

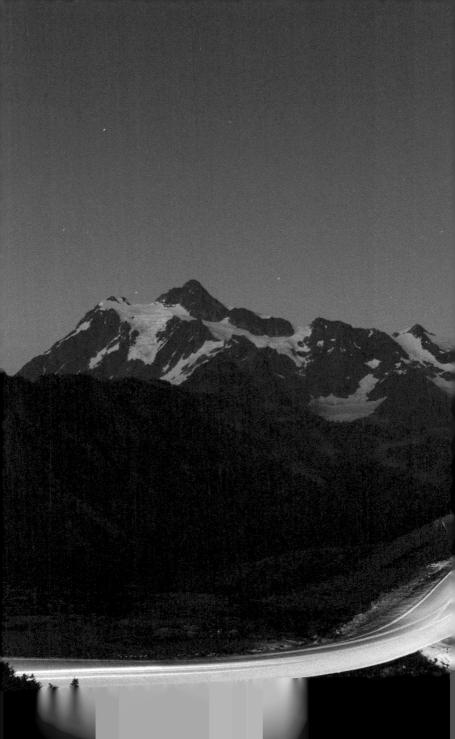

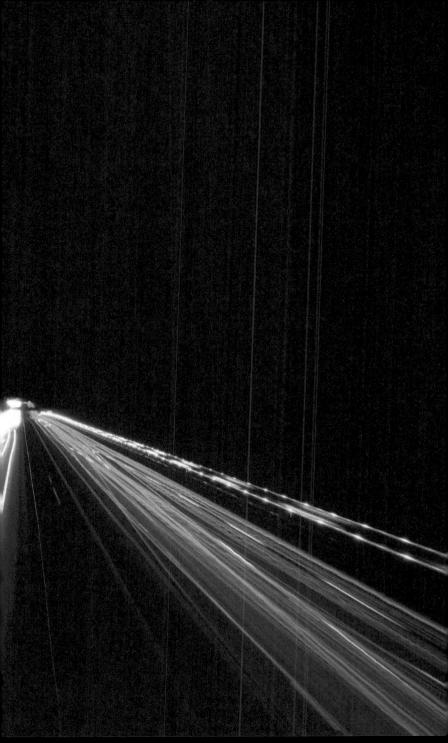

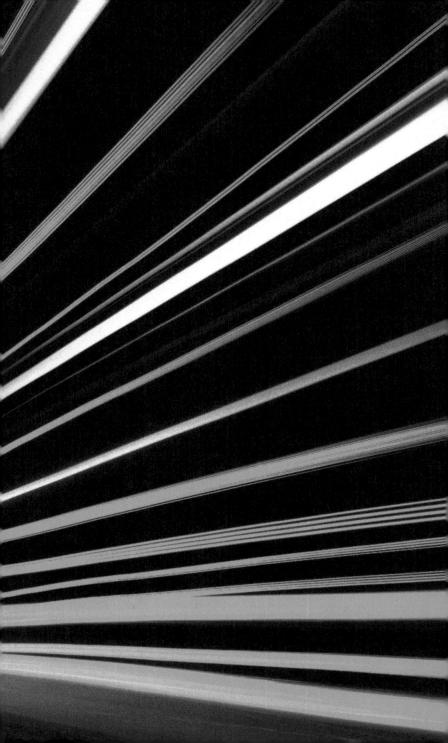

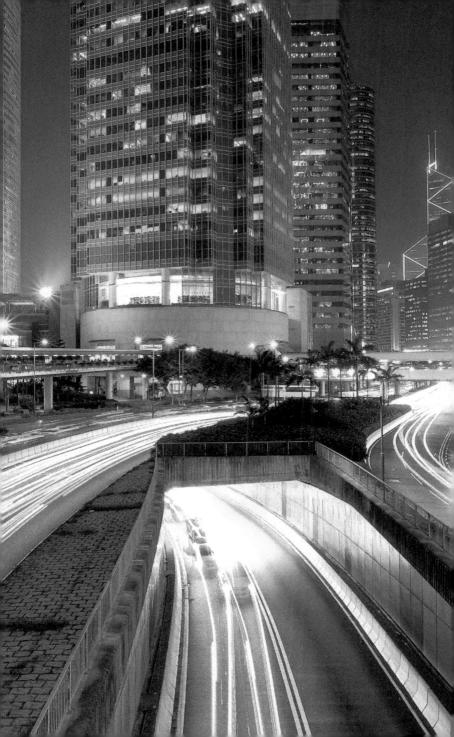

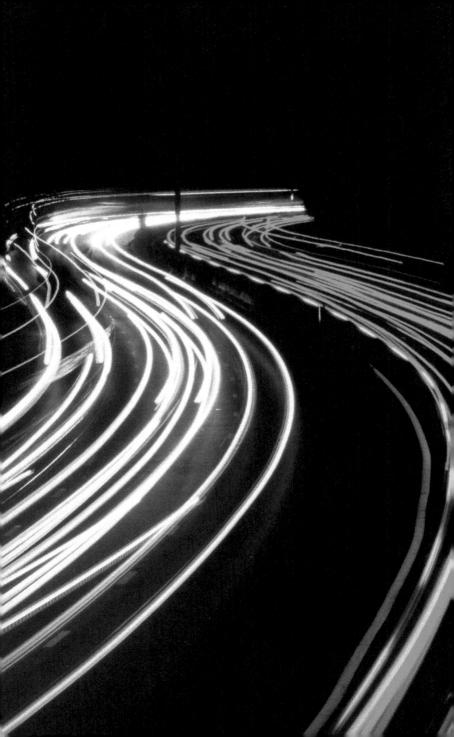

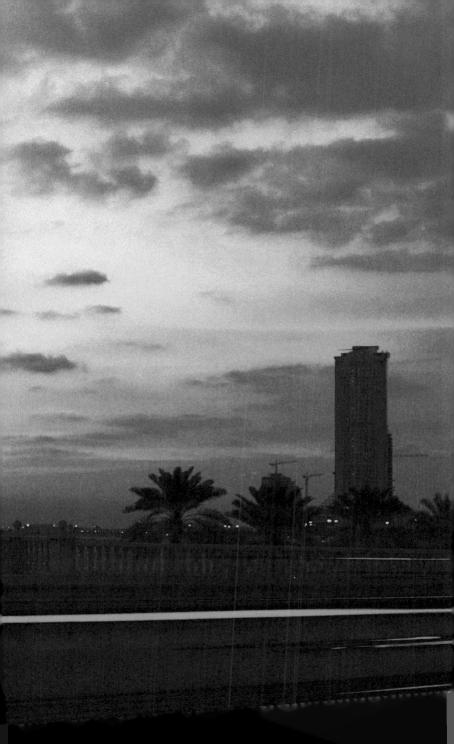

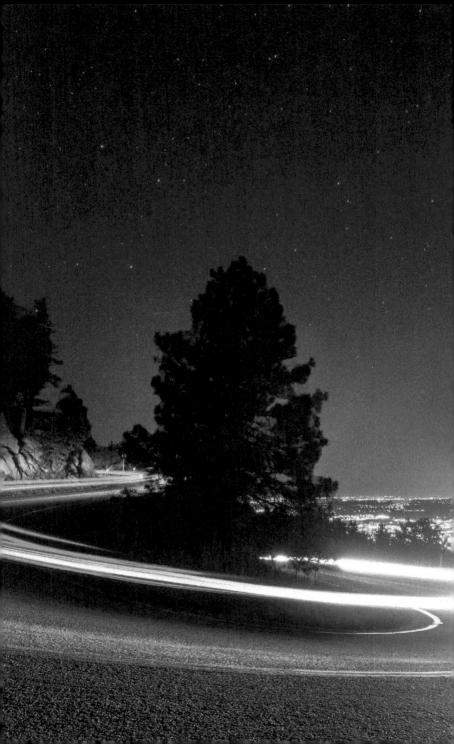

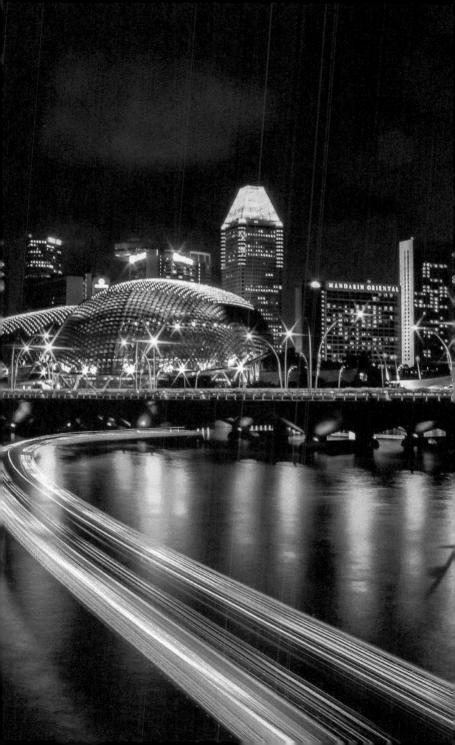

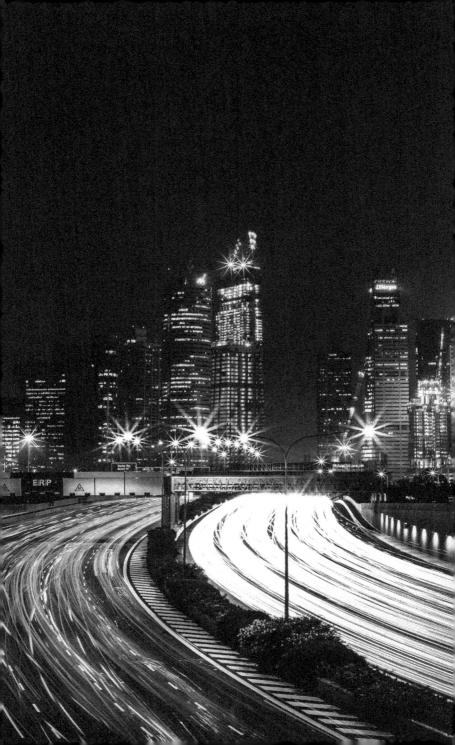

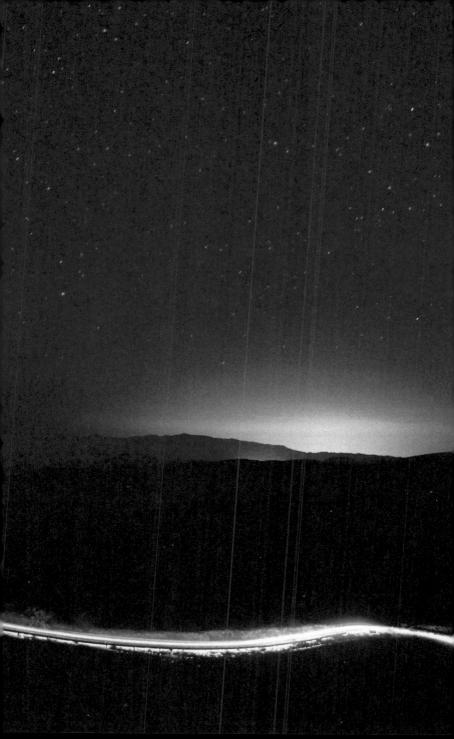

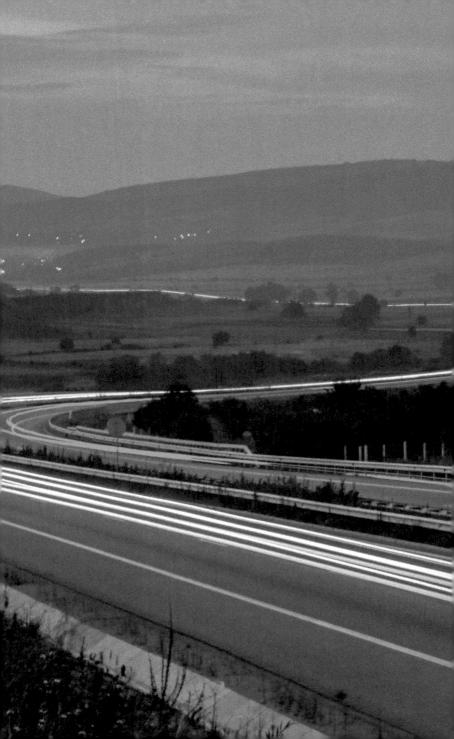

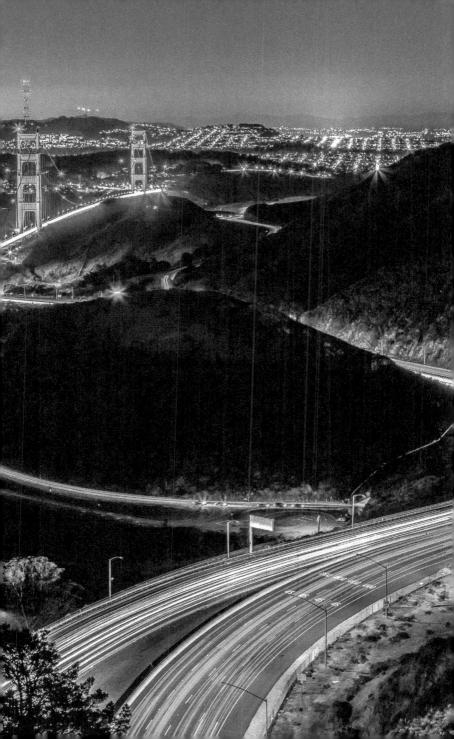

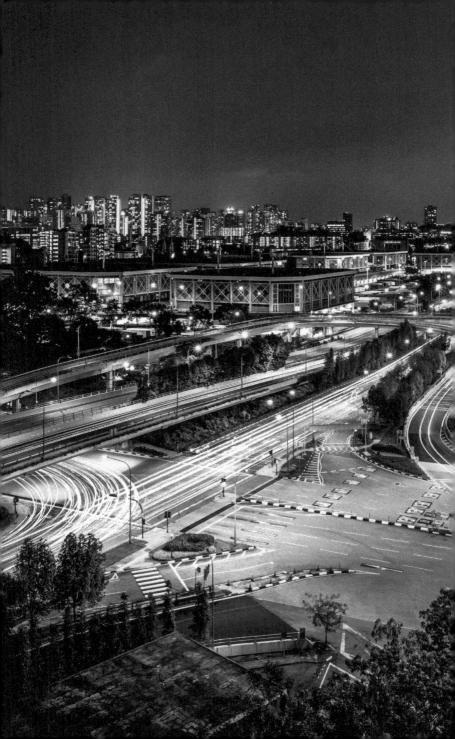